INTIMATE I

triplekite
PUBLISHING

INTIMATE I

I have always been a lover of the subjective photograph. Whenever horizons are excluded, nature is scaled down and the feeling of location is lost. It is then that poetry can take over. To frame a section of a landscape inside the viewfinder of the camera has become my favourite type of photography. To organize geometry and structures over a given surface, is an intellectual challenge that makes my wheels spin. Even at the beginning of my career I pointed my camera towards smaller scaled landscapes and towards abstract expressions of nature. Water has been a favourite subject. I have spent more than 30 years studying the flow of running water, trying to understand its behaviour and how it can be interpreted through a camera lens. What it reflects at a certain time of the day and the way it moves at a given shutter speed are examples of photographic challenges that I enjoy most. I have returned to the fantastic Abisko River Canyon in Lapland, in the high north of Sweden, year after year to shoot specific sections of the river and at specific times of the day. Some images have taken me several years to finalize. I might have seen the potential one year, not quite getting the image I want, and then I have returned the next year at the same time, trying to improve the framing and the usage of light. Sometimes it has worked and sometimes not. The majority of photographs in this book are results of spending lots of time in nature. By keeping your eyes and imagination alert, all of a sudden something interesting might show up in front of your feet. I used to say that in order to get into the right mood you need to become like a hunting Indian: at one with the environment around you. There is an expression in Zen archery which says that: If you are in the right spiritual mode, you will hit the centre of the target as an unimportant consequence. In photography, this means concentration in the field. Great images seldom pop up finished in your camera at first glance. You often have to move around the object, recomposing and work the final image out bit by bit.

Forests and trees are also favourite subjects of mine that, I think, fit within the definition of intimate landscapes. Maybe it is the feeling of comfort I get from the trees around me, but working in a forest makes me both relaxed and concentrated. However the untamed chaos of a forest needs a lot of analysing to come up with a well-composed image. Sometimes a mist can stretch out a helping hand to the photographer, calming down the chaos by fading the background. Like with water photography it takes a lifetime of experience to tame the chaos of a forest and find its backbone. On the other hand, it is wildness and complexity which gives it its life. As in all my photography, I try to get the corners of the composition in harmony and then the rest will often fall in place.

I hope you will find as much pleasure looking inside this little book as I had putting it together. Hopefully there will be two more INTIMATE books in the same format in the near future.

HANS STRAND

4

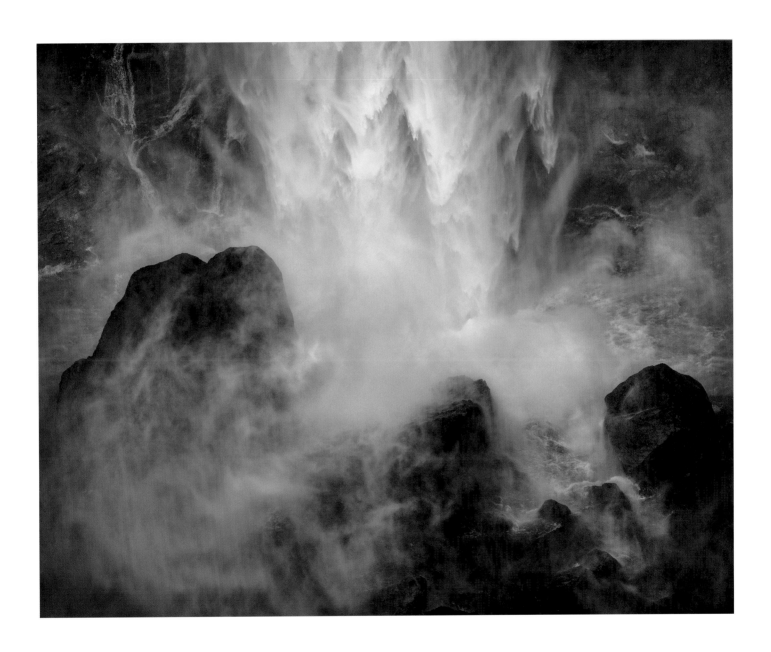

Háifoss, Iceland | June 2013

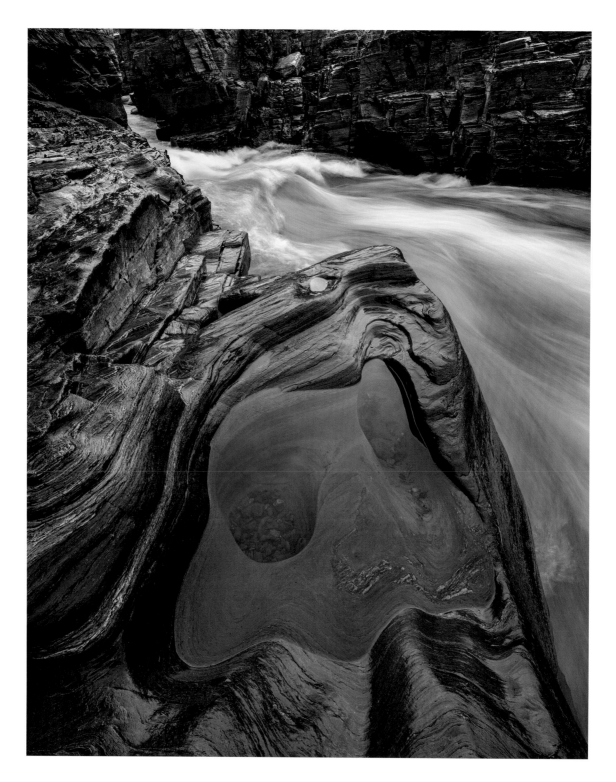

6

Abisko Canyon, Sweden | September 2013

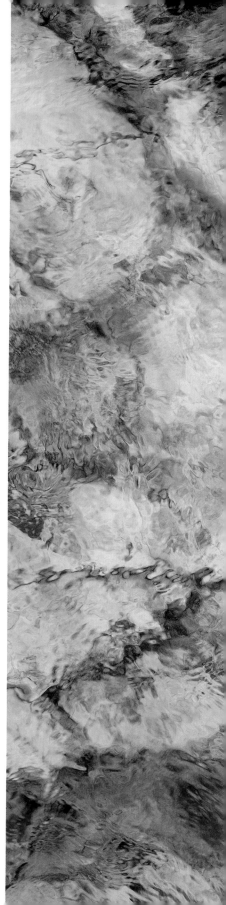

8

Water Over Marble, Abisko Canyon, Sweden | September 2014.

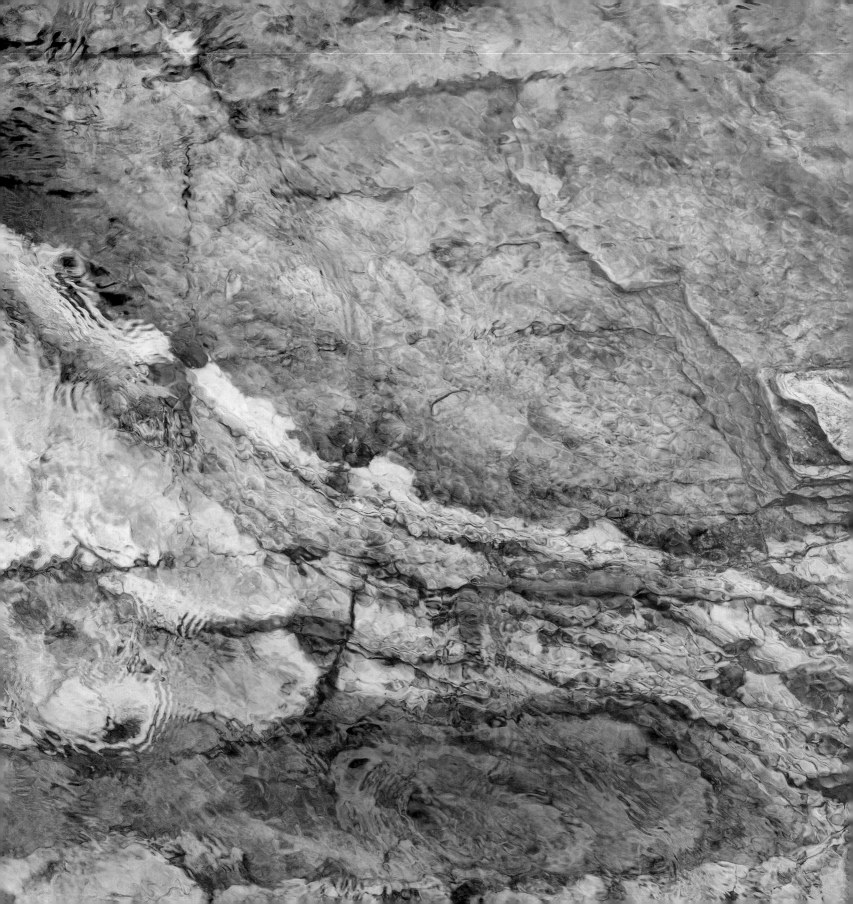

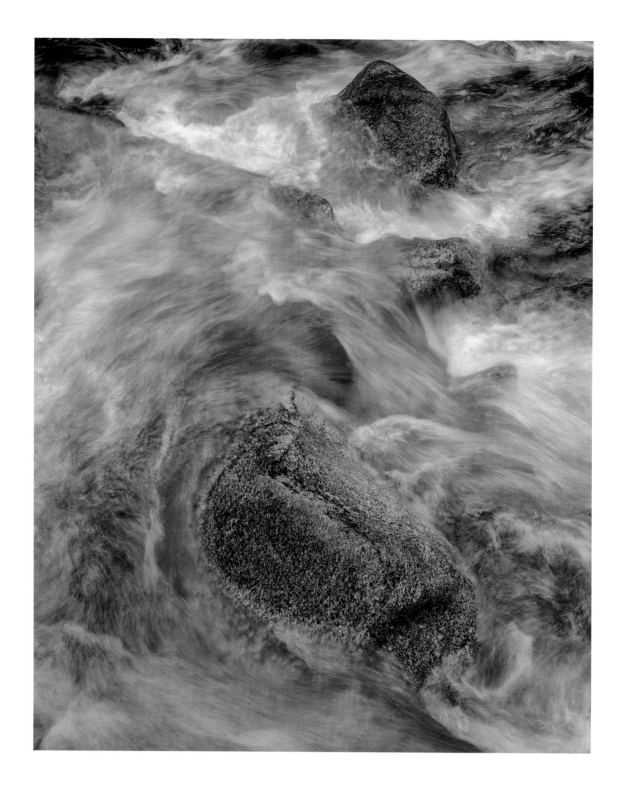

Val Ferret, Italy | November 2013

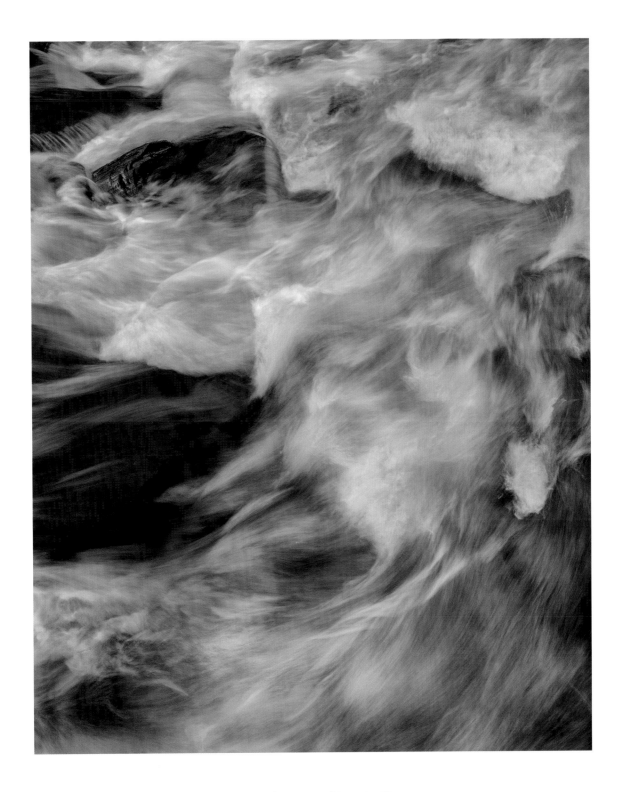

Abiskojåkkå River, Sweden | September 2014

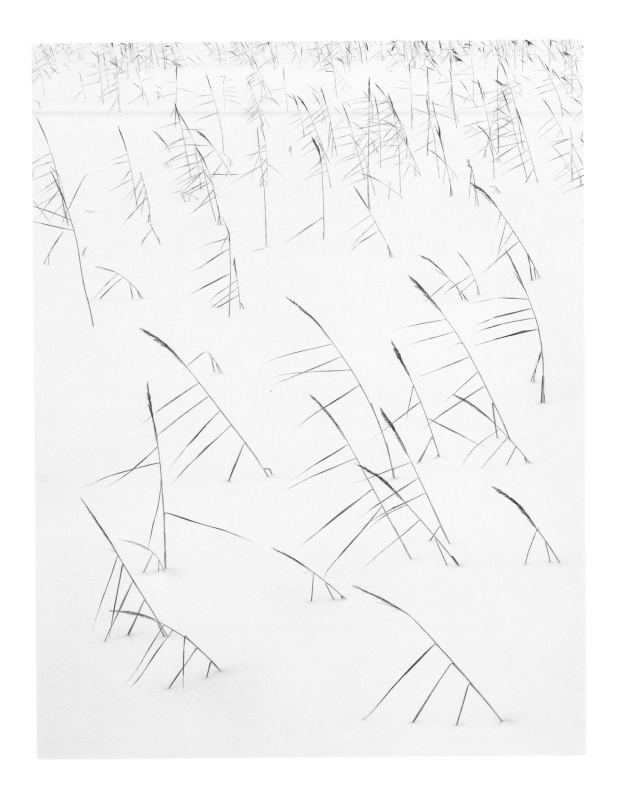

13

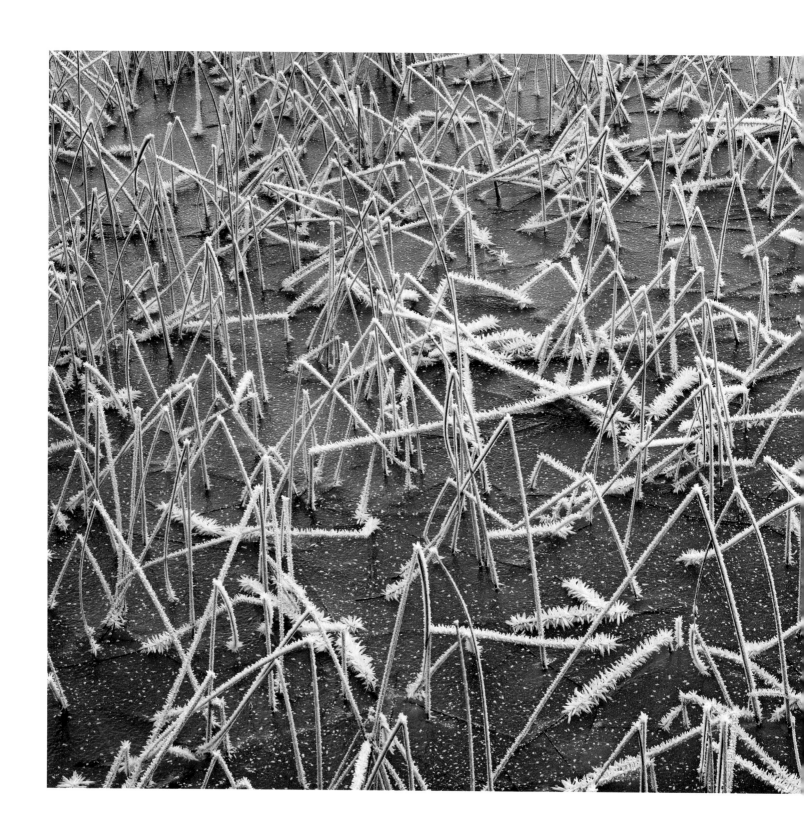

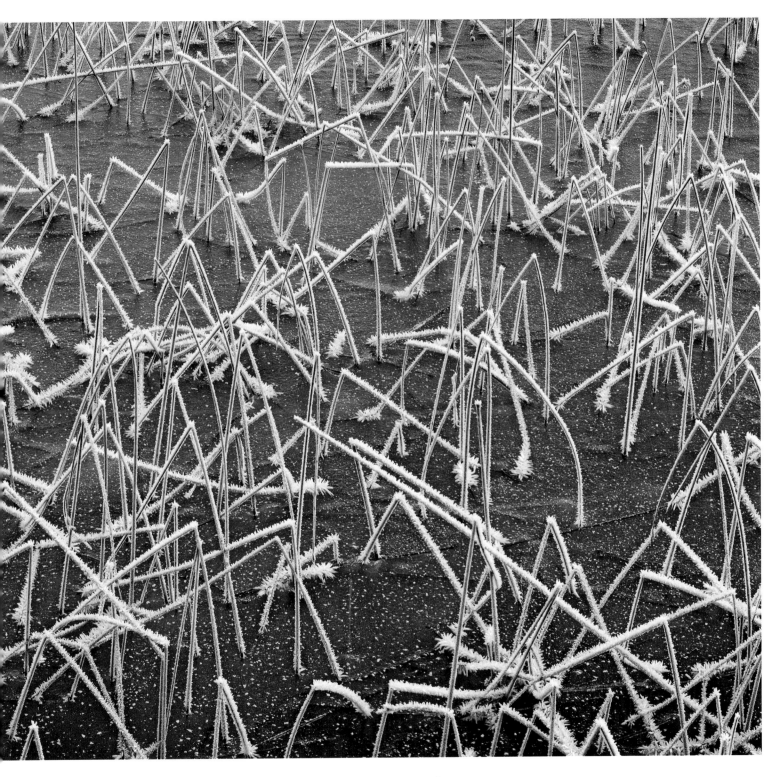

15

Reed, Hornslandet, Sweden | December 2007

16

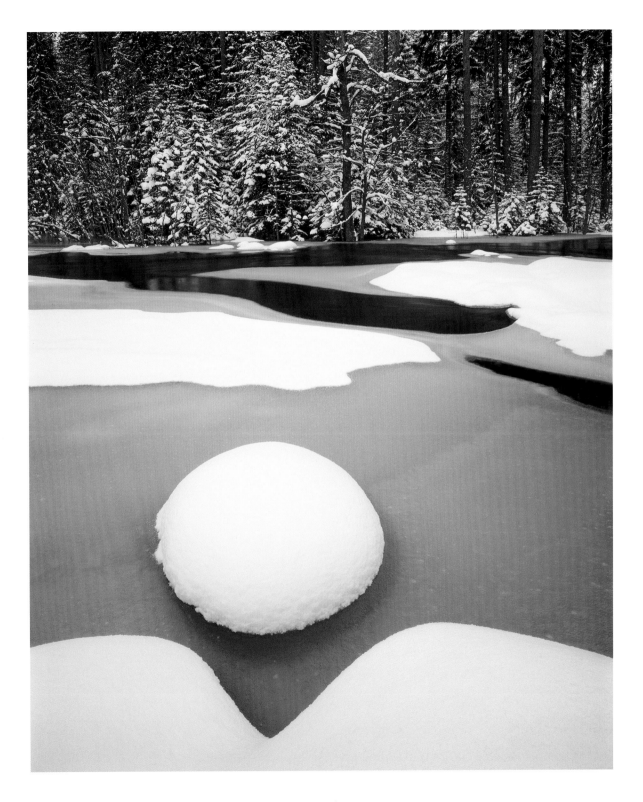

Nianån River, Sweden | February 1992

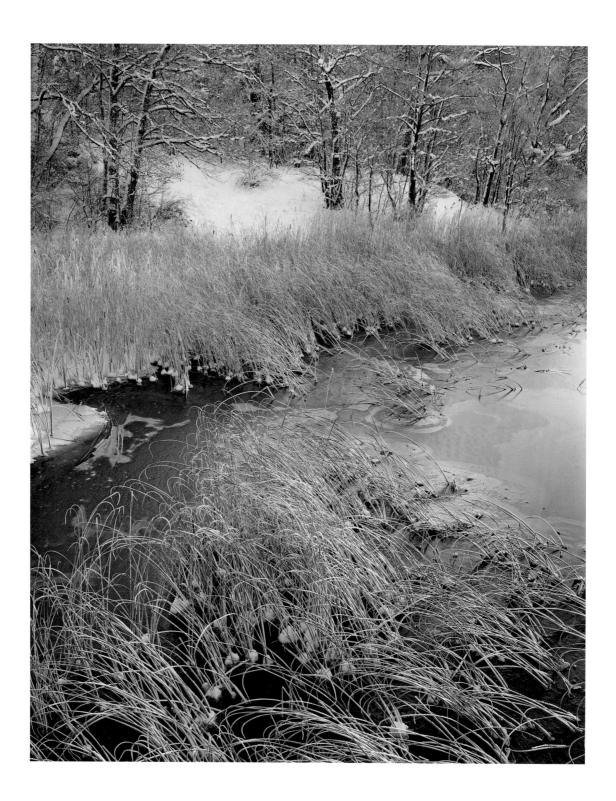

Reed, Lake Mälaren, Sweden | December 2009

20

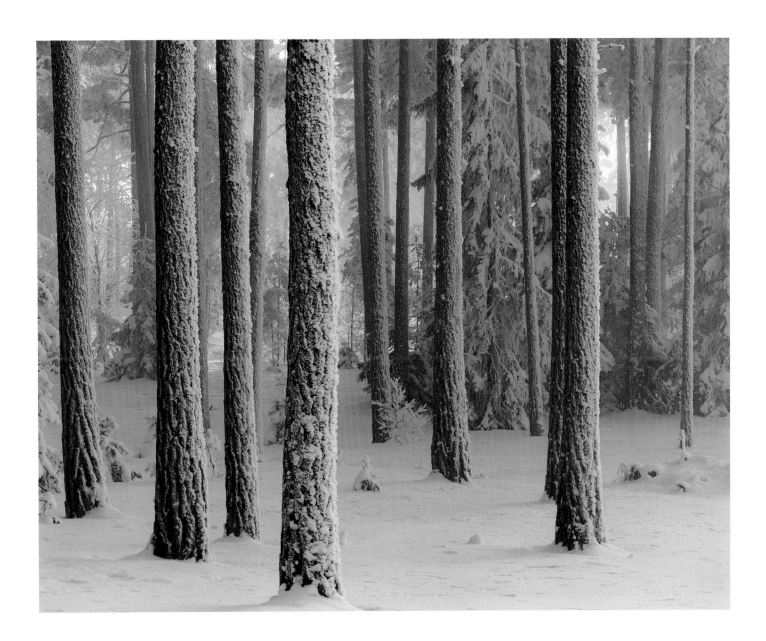

Pines, Kagghamra, Sweden | January 2013

22

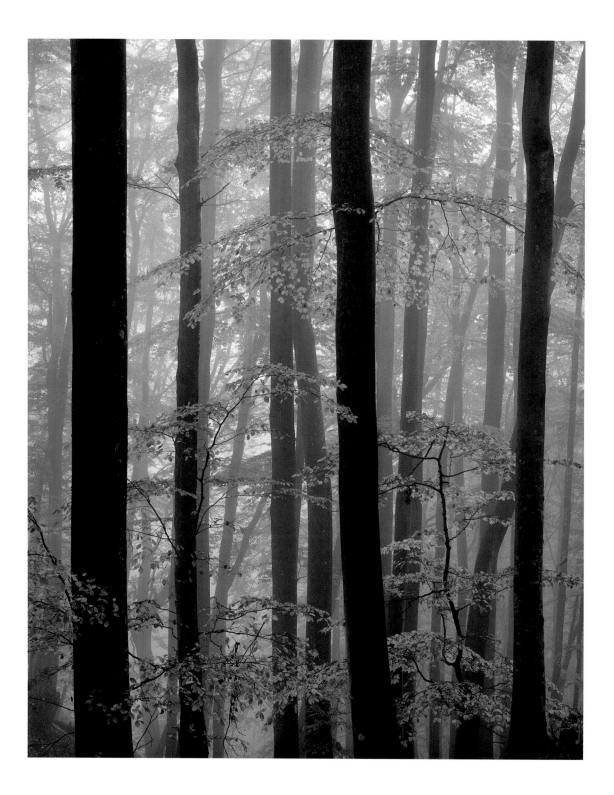

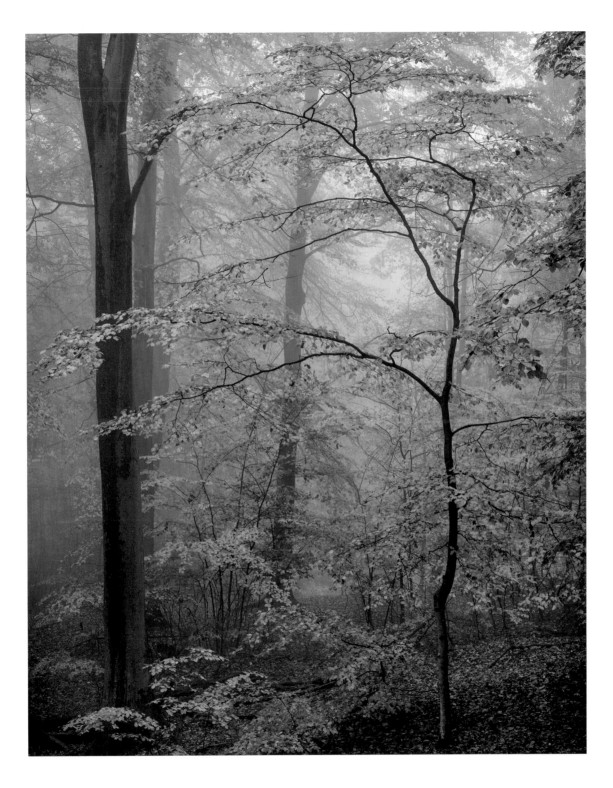

Söderåsen National Park III, Sweden | October 2011

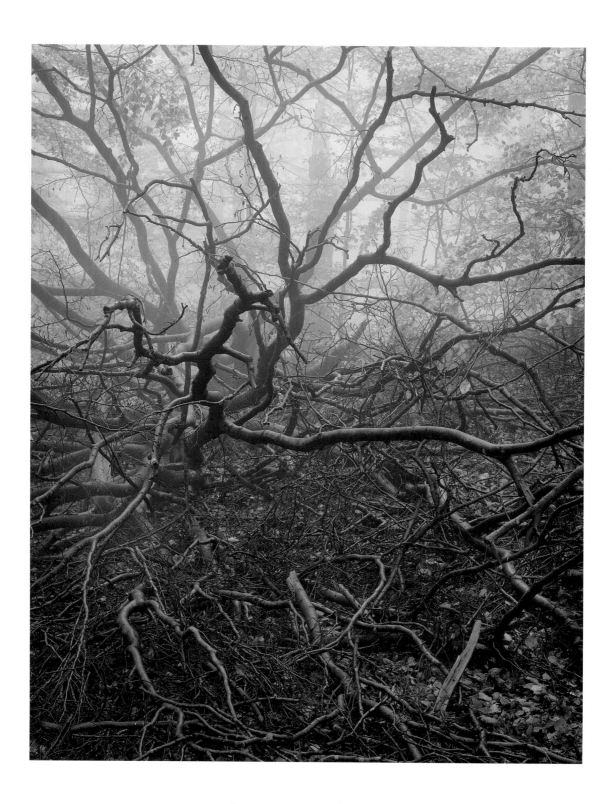

Söderåsen National Park II, Sweden | October 2011

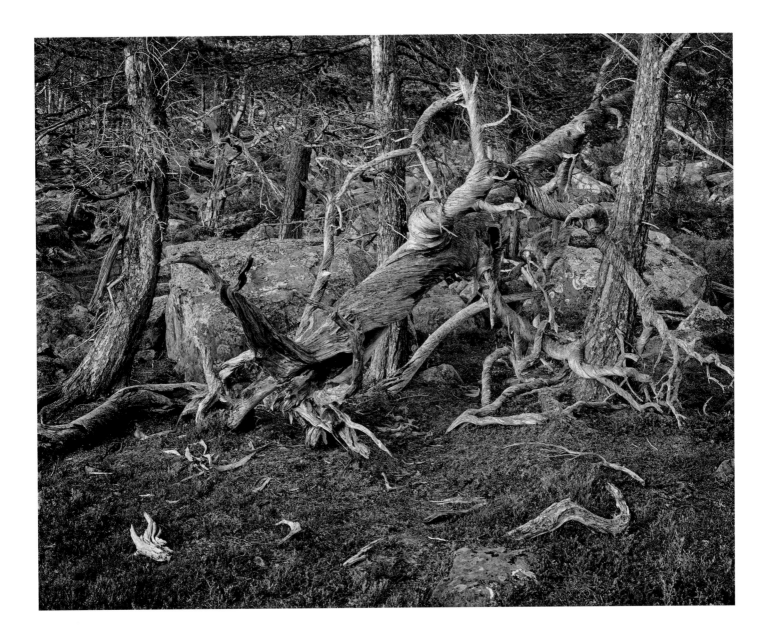

Pine Forest, St Sjöfallet National Park, Sweden | September 1994

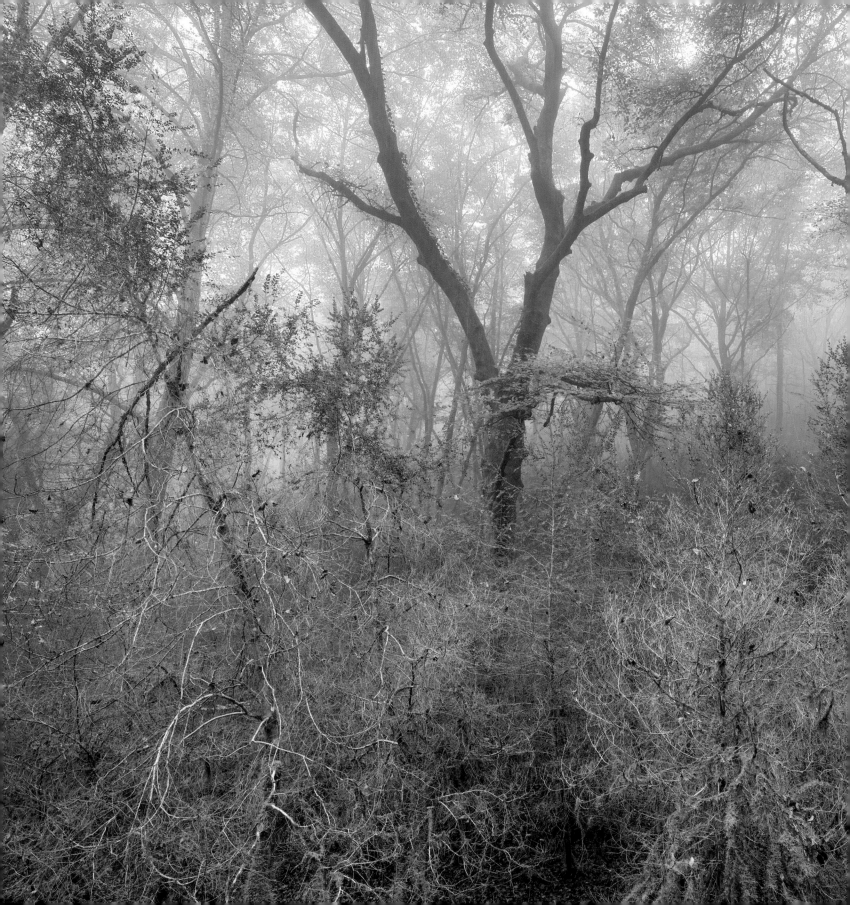

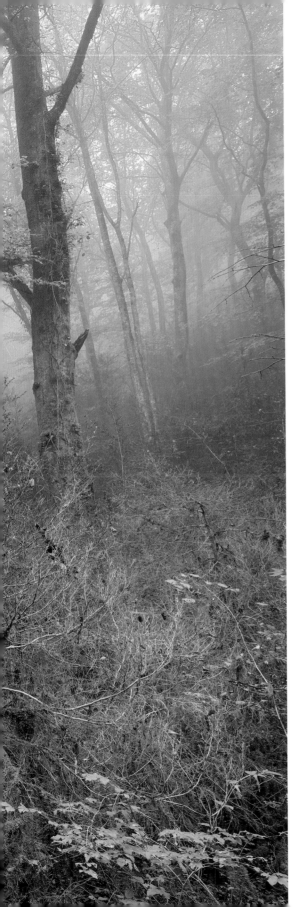

Combe Lavaux, Burgundy, France | October 2014

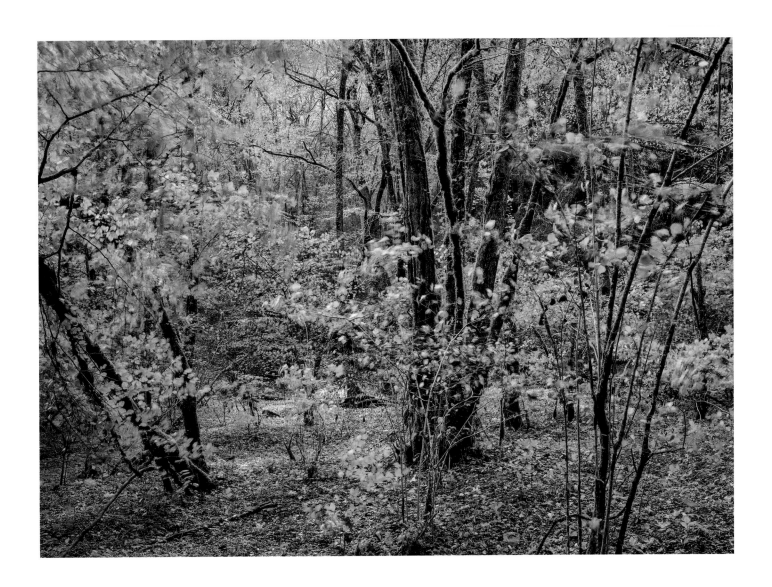

31

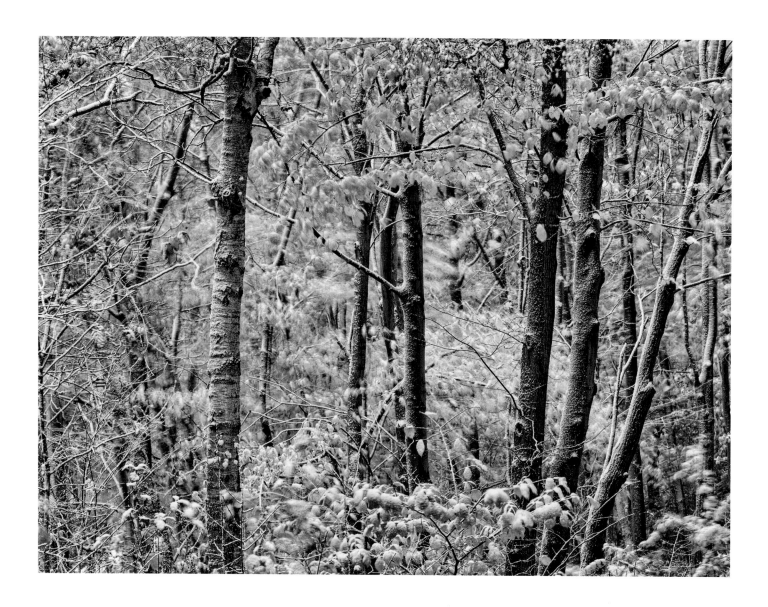

Vinterviken, Stockholm, Sweden | October 2010

34

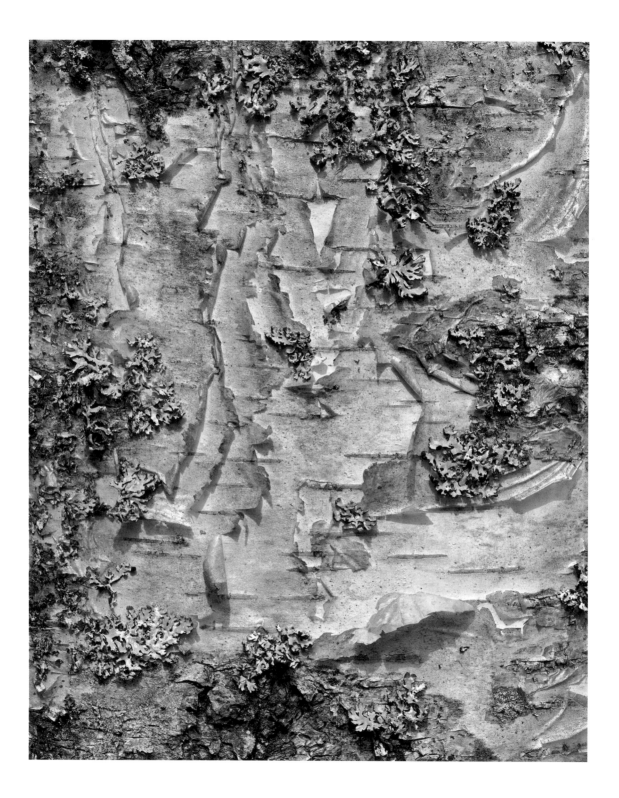

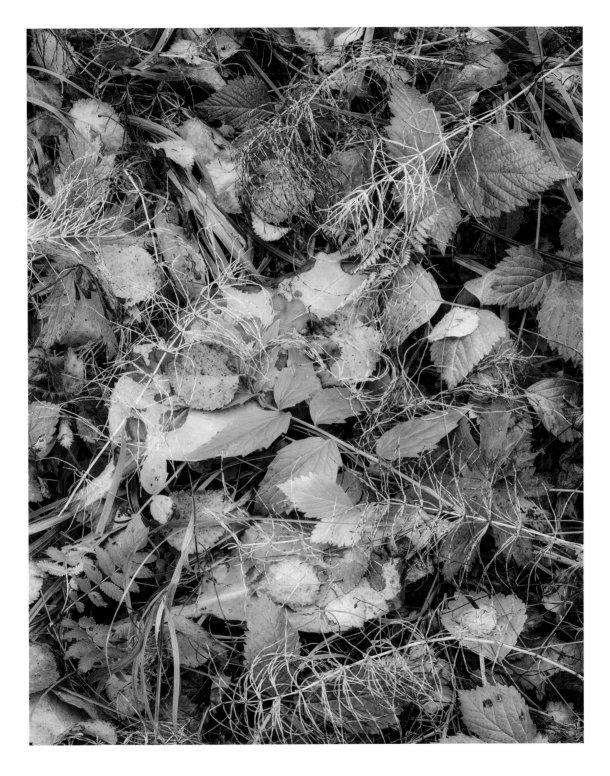

Forest Floor, Abisko National Park, Sweden | September 2014

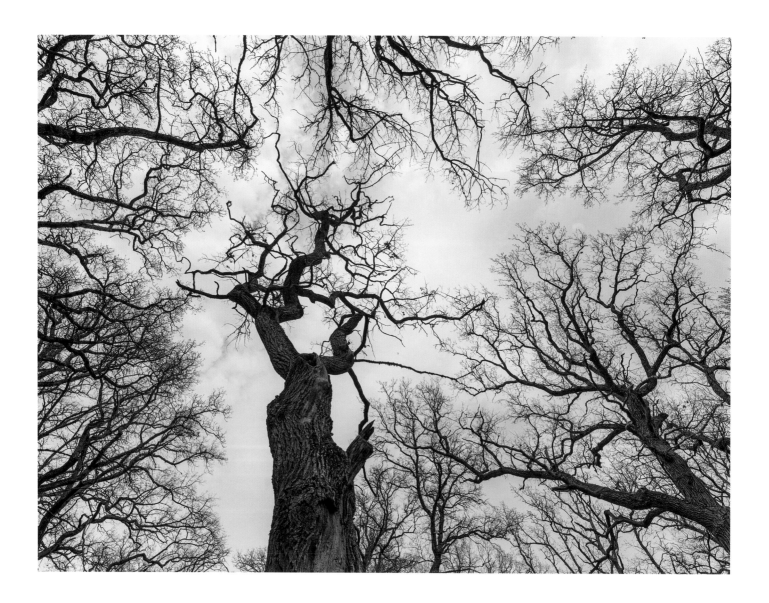

Oaks, Norrmalma, Sweden | April 2014

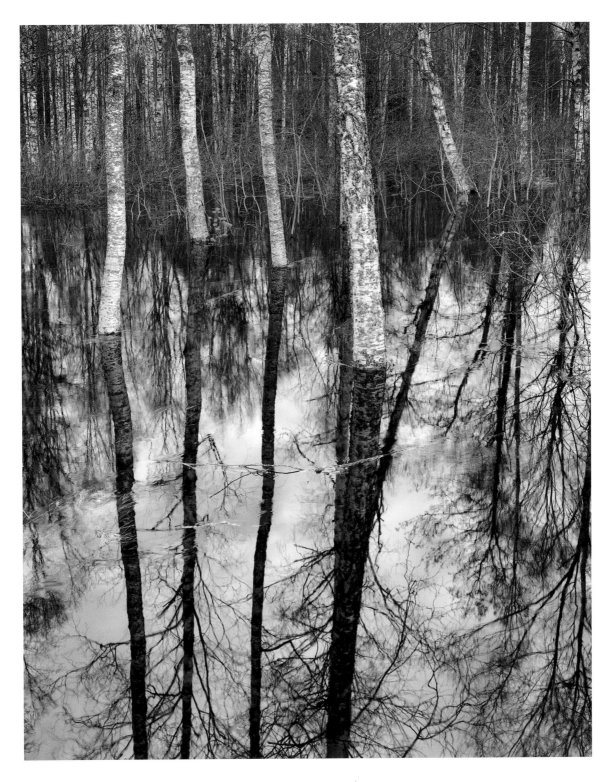

Flooded Forest, Ockelbo, Sweden | April 2011

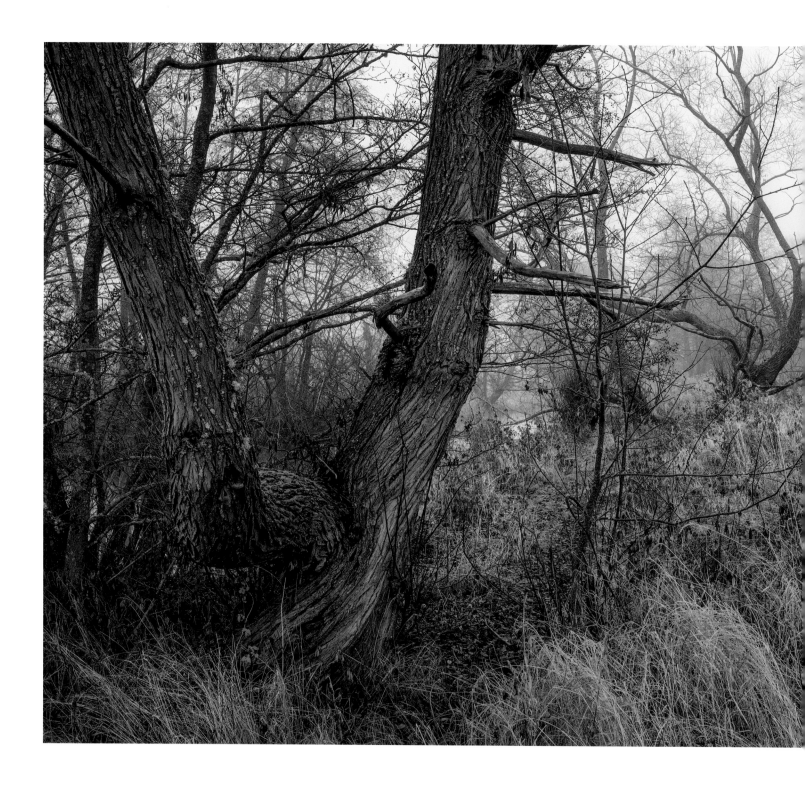

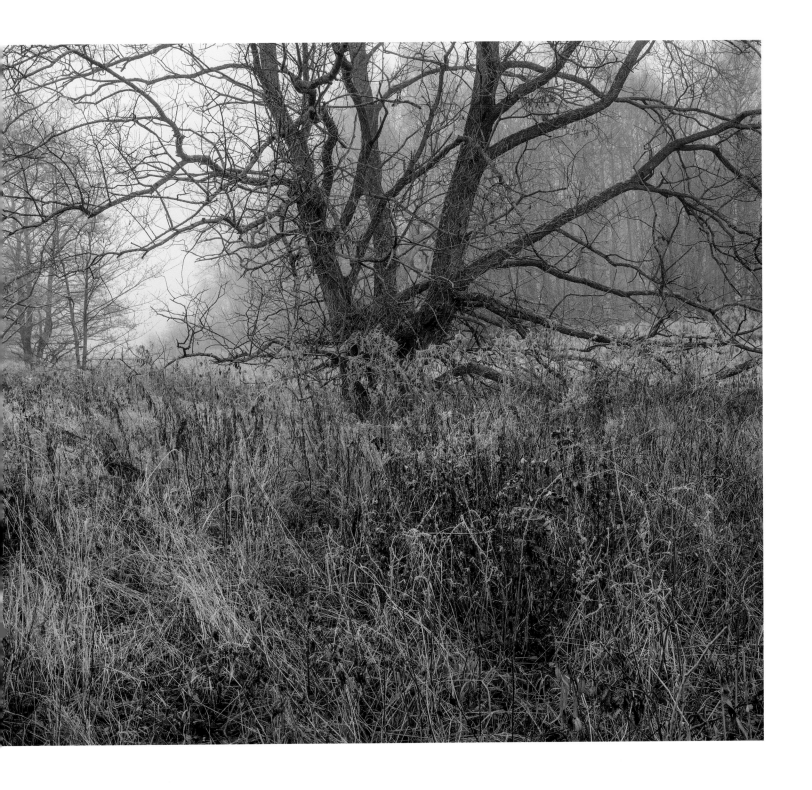

Autumn Mist, Steninge, Sweden | November 2014

40

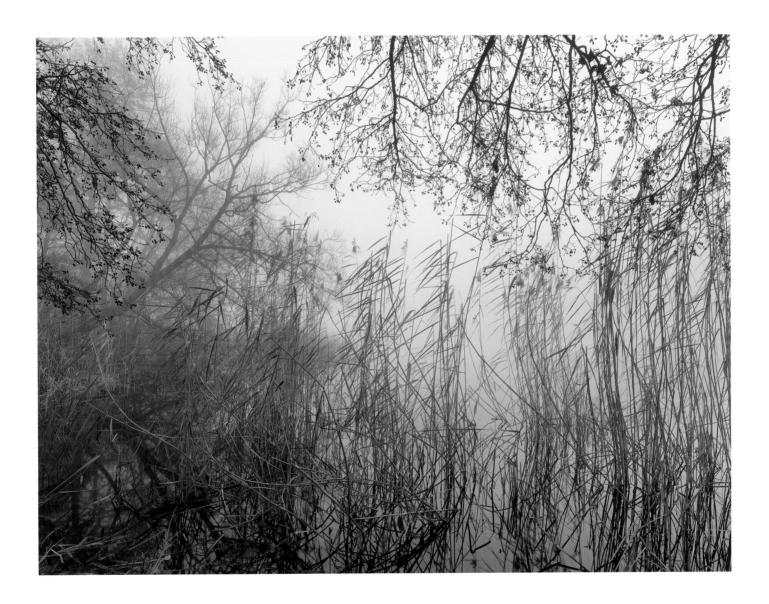

Lake Trekanten, Hägersten, Sweden | November 2009

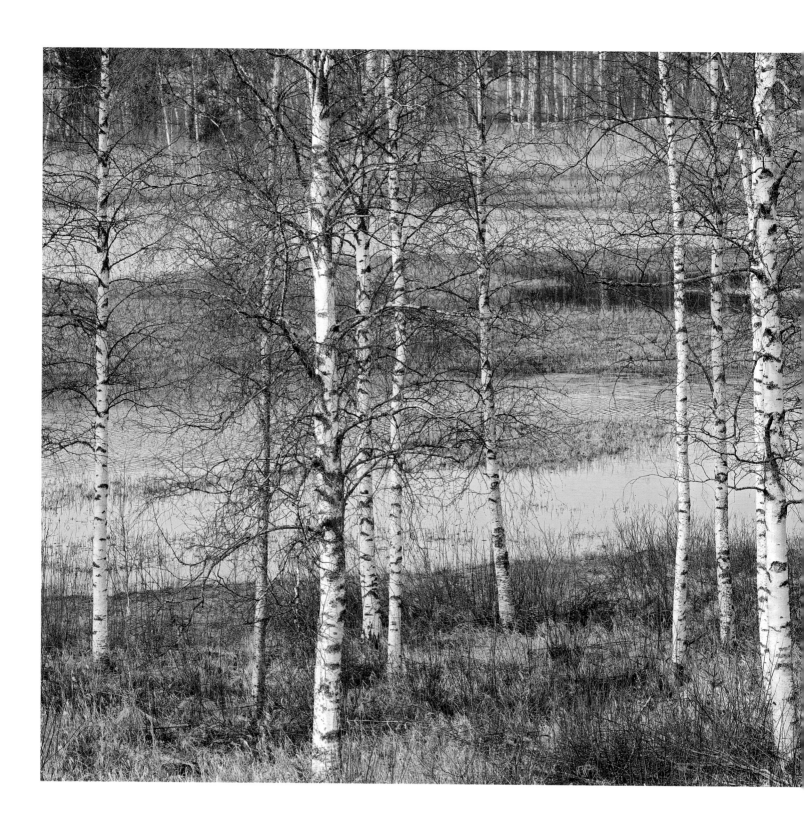

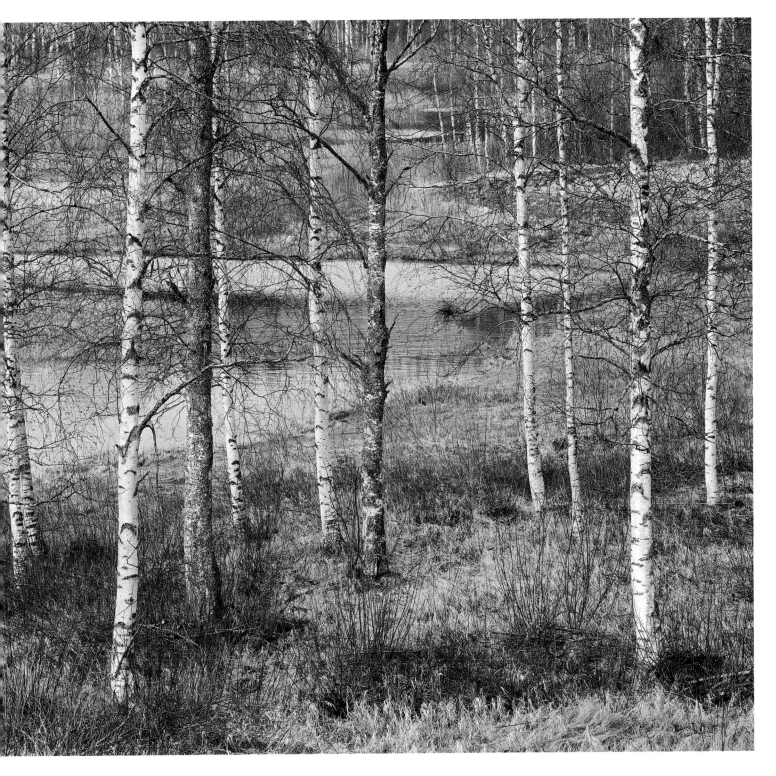

Birch Trees, Roteberg, Sweden | April 2007

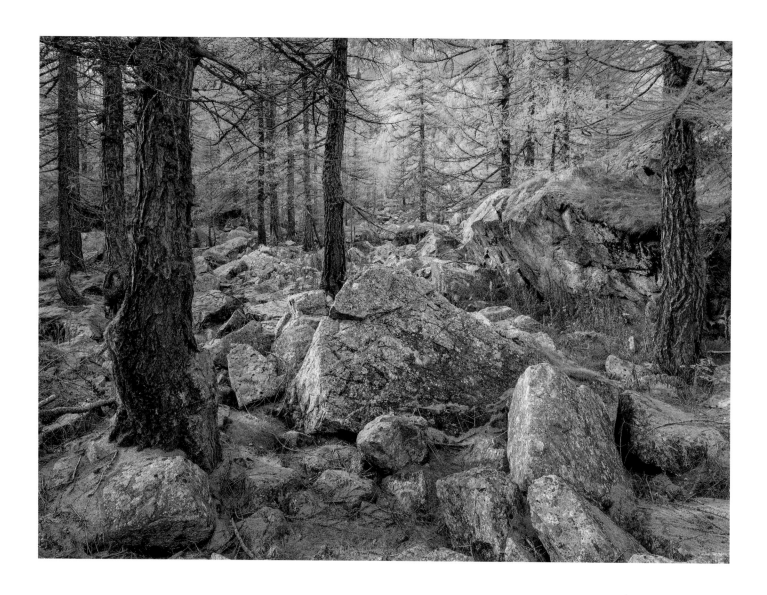

44

Larch Forest, Val Ferret, Italy | November 2013

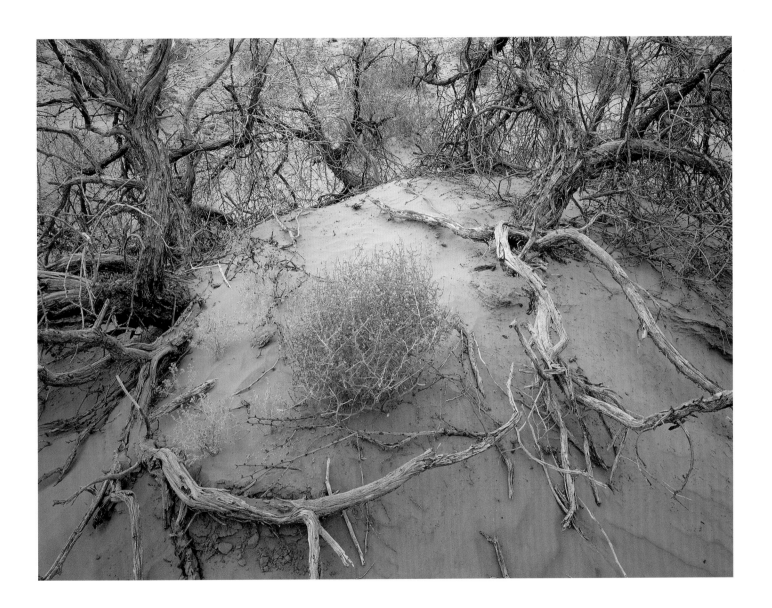

Death Valley, California, USA | February 1999

Intimate I is available in three editions.
As well as the Standard Edition, the book is also available in a special edition of 50 with an A3 print, or a Luxury Edition with two A3 prints.

Fotospeed
PROFESSIONAL INKJET MEDIA & INKS

Limited edition prints archivally printed on to Fotospeed papers.

First Published 2015

ISBN: 978-0-9932589-1-6

Designed by Dav Thomas. Printed in Malta